MEDIOCRE SUNFLOWER

FELIX

Dedicated to
our inner child
battling the flames
of the world.

And to my mother,
thank you.

"I am a traveler,
going somewhere
and to some destination...
only the somewhere
and the destination
do not exist."

-Vincent Van Gogh

INTRODUCTION

I am not special and neither is this book.
Yet, somehow it sits in your hands,
waiting to speak with you.

I've been told a thousand different ways
on how to introduce it,
and I choose none of them.

Mediocre Sunflower is raw.

Birthed in dark drunken nights,
blissful adventures,
and floating in the black hole
of my imagination.

Inside, you'll find several different narratives.
Yes, there is a meaning to Mediocre Sunflower,
but that is for you to find.

Flip to any page and let your story begin.

All of my love,

FELIX

THE APPLE
STARED
AT THE
TREE
ABOVE HIM
WITH A
GENTLE
THOUGHT

"I do fall far"

The hourglass sits on the shelf of the Universe.
Our sand forever falling to the bottom.
Yet we always tell ourselves,

I have time. I have time. I have ti

KEEP THE WHISKEY FLOWING
FOR THIS LONELY SOUL.
THAT FRIENDLY LIQUID
WHEN I AM ALONE.
A FEW CUPS LATER,
I'M MORE AT HOME
WITH SOME WARMTH
HEATING MY BONES.
WHISKEY HAS ALWAYS BEEN
A DEAR FRIEND.
I IMAGINE
IT WILL BE THAT WAY
EVEN IN THE END.
WHEN ALL FRIENDS
HAVE DITCHED ME
I'LL GET A KNOCK
ON MY DOOR.

"who is it?"

"W H I S K E Y!
 L E T M E I N!"

HE KNOWS MY HOUSE
IS SILENT
AND NOBODY IS THERE.
SO WHEN HE KNOCKS,
I LET HIM IN
WITHOUT ANY CARE.
WHISKEY,
YOU SLY MOTHERFUCKER.
YOU KNOW I'M A BROKEN SOUL
BUT GODDAMNIT
WHEN YOU COME OVER
I FEEL WHOLE.

A flaming disconnect
in the city of angels.
Where the angels lose
their wings trying to
become Gods.
Forgetful
of their own grace.
Chasing the fantasy
of jeweled crowns
when they already
possess golden halos.

O LOVELY LADY
PLEASE LET ME IN
I SAW YOUR GARDEN FROM AFAR
SO HERE I AM
AT THIS NORTH STAR
I AM BUT A PEACEFUL PILGRIM

O PILGRIM
YOU ARE NOT THE FIRST
TO SPEAK
OF PEACE
MANY HAVE COME AS WOLVES
CLAIMING TO BE SHEEP

O LOVELY LADY
THOUGH THAT MAY BE TRUE
I AM A SHEPARD
THAT WILL KEEP FILTHY DOGS
AWAY FROM YOU
FOR WHAT THEY DID TO YOUR GARDEN
IS A SIN
I PROMISE
IT WILL NEVER HAPPEN AGAIN
IF YOU LET THIS GENTLE SHEPARD IN

O SWEET SHEPARD
YOU ARE A POET WITH YOUR TONGUE
BUT ONCE I LET YOU IN
YOU'LL SNATCH MY FLOWERS AND RUN
MY GARDEN WILL BE EMPTY
AND I ALONE

O LOVELY LADY
I WILL CALL YOUR GARDEN
HOME

Mother Nature
touched my cheek,

"Mankind
 has been cruel to you."

Frozen
in the face of beauty,
I hear the whisper,

"I know
 the feeling all too well."

The smell
of cheap cigarettes and unwashed men.
The sight
of a bar from Bombay Beach.
The sound
of an aging jukebox playing melted jazz.
The time
dictated by a clock that no longer ticks.
A place
where men hide from the light of day.
The drink of choice: Sorrow on the Rocks.
Torn leather chairs that screech at any movement.
Mine doing its job with the overtime of chafing my ass raw.
The man to my left, a quite ugly fellow,
turns his gaze from the stale peanuts towards me.
Rugged black eyes foreign to sleep.
A drag that burns the whole cigarette is exhaled into my face.
Before the ugly man knows it,
a puff of my own slaps his scarred up cheeks.
"You're too pretty to be in here."
"And you're an ugly son of a bitch."
"Well, I guess that makes us even."
Sluggishly he tilts his glass towards mine.
Enemies turned allies with a clink.
Breath full of Jagermeister and gingivitis, he peers closer.
"What ya in here for?"
I return the question and am greeted with,
"I asked first fucker."
A gulp of whiskey ties my answer to the raven and releases
it from its cave.
"If a man's father is evil, what blood runs through his veins?"
Tapping his dirty fingernails, the ugly man faces forward.
"Well that's just a shit question."
His tongue slithers out to water the scar protruding into his lip,
"You got all your life to figure that one out kid."
We order another round in search of the answer.

You see the degree,

but what you don't

is all the pieces

it took out of me.

"You athletes get educated for free!"

Yet these scars

are the receipts

of my currency.

I DON'T DATE.
I CAN'T SIT ACROSS THE TABLE
AND EVALUATE
WHETHER THIS FACE
IS A SOUL MATE.
QUESTION AFTER QUESTION
WE WEAR OUR MASKS
HOPING THE OTHER BELIEVES.
KNOWING THE INFLATED WORDS THEY SAY
ARE JUST STRATEGY INSIDE OF A GAME.
WE MIGHT AS WELL BRING
RESUMES,
HOROSCOPES,
AND CREDIT SCORES.
CAUSE HERE AT THIS TABLE,
WE SAY
WE'RE LOOKING FOR LOVE,
BUT IN TRANSLATION
WE'RE FORCING IT
WITH AN
EXPECTATION FILLED GUN.
WE DIG A DESERT EAGLE
TO CUPID'S TEMPLE
AND SCREAM,
"Give love to me!"
SPITTING BLOOD THAT PAINTS THE FLOOR
IN A CARDINAL SPLATTER
HE WHISPERS,
"love is not your creation.
 it is a gift from above. you must-"

B A N G !

WHO WOULD HAVE THOUGHT
MAN MADE LED
COULD CRACK A GOD'S SKULL
JUST AS EASY AS OURS.

YOU THROW THE BODY TO THE SIDE,
PULL OUT THE PHONE WITH WIDE EYES
AND SWIPE RIGHT
ALL THROUGH THE NIGHT
UNTIL YOU GET ONE THAT BITES.
YOU SEE,
I DON'T DATE.
MY ANGEL AND I
WILL FIND EACH OTHER SOME DAY.
TILL THEN,
I'LL WAIT.

THE SKELETON WAKES.

CLICKS & CLACKS

TO THE CLOSET OF ITS SKIN.

LOOKS TO ITS MASKS

& CHOOSES THE GRIN.

FULLY DRESSED

THE MIRROR SHOWS A PERSON

WHO'S ALIVE.

ALL THE SKELETON SEES

IS HOW DEAD IT IS INSIDE.

HOPEFULLY one day

in the NEAR future

men will see WOMEN

in all their STRENGTH

&

women will see MEN

in all their TENDERNESS

Twenty thousand followers.

Ten thousand likes.

Four thousand comments.

And one broken heart.

Here on this dirty old sidewalk
are the stains
of a mother and a son.
The woman
who never found a good man.
The boy
who watched them treat her like a garbage can.
Shoved in rose bushes,
called a stupid whore,
slapped in the face,
humiliation trickling into her core.
The cowards always ran out
leaving a battered woman behind.
And every time,
she found herself
on that dirty old sidewalk.
By the time she sat down,
her little boy
was tending to her wounds.
Wiping the tears from her eyes.
Picking the thorns from her skin.

"mom, please don't let him do that to you again."

"I promise, I promise,
 but listen baby,
 never treat a woman this way."

The little boy thought,
if only mom could see the man I'll be one day.

Soft little fingers
tracing
hard worked hands.
They sit aglow in the moonlight.
The purest love
isolated on these sacred nights.
A mother and a son
forever holding
the other one
on that dirty old sidewalk.

PLUNGE INTO THE CANVAS OF THE WORLD
TO MEET A HEAVENLY GOLDEN WOMAN
FORGED BY KLIMT
WHERE YOU SIP RENOIR COFFEE AT THE
'BAL DU MOULIN DE LA GALETTE'
THERE
YOU FALL INTO AN ABSTRACT LOVE
CRAFTED BY PICASSO HIMSELF.
TIME WILL MELT AWAY
CEASING TO EXIST
THE WAY THE GREAT DALI INTENDED
AND
MAY YOU LIVE
THIS HAPPILY EVER AFTER
IN VINCENT'S
STARRY NIGHT.

Setting her paint brush down
she asked me

"Why didn't it work out with the last one?"

Sipping the last drop of whiskey
my voice thickly cracked

"She wasn't an artist."

She shook her head with a smile
locked, loaded, and fired,

"My oh my, does your narcissism ever grow tired?"

The phone rings.

"Hey thanks for interviewing for the job, but
 we're going to go in a different direction."

Punch to the gut.
Hole in the bank .
Pressure cracks my bones.
The life you wanted!
Creative is what you get to be!
Yet the shackle of insufficient funds
prevents me from flying free.
Well, you wanted to be an artist.
Whatever that means.

"Sir, are you okay?"

Snapped out of silence.

"Yeah. I'm great."

I dreamt
I was inside
my childhood room.
The cheap
glow in the dark stars
dimly shine on the ceiling.
My Lion King blanket
lays unmade on the bed.
The toys
still scattered
across the floor.
In the corner
sits my mother.
Her youth
provides
the only light.
She looks to me
and says,

"Baby,
 I've been trapped here
 for so long. When you wake,
 come find me and I will listen."

Without speaking
I ask
Where are you?

She holds up my favorite toy
and the room dissolves
into a thousand colors.

TO HAVE A LIFE OF
STABILITY
AND
SAFETY
OR
TO LIVE A LIFE OF
UNPREDICTABLE ADVENTURE.
STARING INTO THE BLACK COFFEE,
SHE GREW BORED.
THE CREAM SWIRLED INTO HER CUP
LIKE A GHOST DANCING WITH THE SEA.
THE WORDS FLOATED OFF HER TONGUE,

"That's more like it."

WE
MUST
SCRATCH
AND
CRAWL
UP
THE
STEM.
THE
THORNS
MAY
CUT
BUT
ALWAYS
REMEMBER
AT THE END
A FLOWER AWAITS

I

AM

A

MAN

IN CONSTANT FEAR

OF

ALL

THAT

I

AM

NIGHTS LIKE THESE
AS MY HOME
SITS SILENT
I WISH I HAD
THE WOMAN.

us
laying in bed
folded
into the other.
old records play
while we share
unheard stories.

NIGHTS LIKE THESE
I AM NOT SAD.
I AM QUITE HAPPY.
SHE
CROSSES MY MIND
AND I,
YET TO KNOW
HER NAME.
FOR SHE ONLY
VISITS ME IN MY DREAMS.
HER BEAUTY
OVERWHELMS ME
YET EVERY TIME
I WAKE
I FORGET HER FACE.
BUT HER PRESENCE..
AH YES,
HER PRESENCE
IS REMEMBERED.

Dear Vincent,

I write you from the other side.
Of time or place or feeling,
I'm not entirely sure.
Hopefully you are well.
And by well, I mean creating.
Many people wish happiness to others,
although appreciated,
people like you,
like I,
find those wishes rather confusing.
If we were always happy,
would there even be a point to life?
In my pain, my most truthful work comes to life.
And when happiness comes back around, it is fully appreciated
Here I am rambling on...
The reason for this letter,
if I had to boil it down to one theme:
I am confused.
Whether or not I am any good at this.
If I am wasting my time.
If I am a weightless phony.
So many artists crave to be recognized,
and while I cannot dispute that,
I wonder if success is for me.
To be clear, I do not create for riches.
I create because I would rot if I didn't.
'It' brings life to my soul.
Oxygen into empty lungs.
Is that the point of 'It'?
To make 'It' or die?
I feel so much and don't know what to do.
In those piercing moments I want to end it all,
but something always keeps me from doing it.
Maybe it's God.
Maybe it's my ghost from another life.
Maybe it's you.
One thing is certain.
Until we meet at eternity's gate,
I must continue to create.

RUNNING WILD
WHEN THEY
DEMAND US NOT TO

THEY SWEAR
WISDOM IS ON THEIR SIDE
AND MAYBE THAT'S TRUE

YET THEY SECRETLY
WISH
TO RUN WILD
THE WAY WE DO.

A woman
intelligently captivating
as she was divine
seized my curiosity
in that moment of time.
The day we met,
I was deeply convinced
I had found gold
in a city malnourished
to its bone.
Until one day
she told me over the phone,

"I'M 27. YOU'RE 25.
 I LIKE YOU A LOT BUT,
 I NEED TO BE DILIGENT
 WITH MY TIME.
 JUST GOT OUT OF A FIVE YEAR
 RELATIONSHIP A FEW MONTHS AGO
 AND ALTHOUGH YOU'RE FUNNY AND CUTE,
 I HAVE TO LET THIS GO.
 UGH.. TO BE HONEST,
 LET ME MAKE IT CLEAR,
 I NEED TO FOCUS ON
 MY CAREER."

I sat in heavy thought for the next few days.
Maybe, I was just a lousy lay?
Or boring bed.. nah.. nah.. no way.
I teeter tottered what matters most
when we take our final breath
before becoming a ghost.
Will we think of the extra hours
we put into a linear career?
Or will we feel the love we gave
in the short time we were here?

Every soul on this planet
flying through space
will have their own answer
in that given time and place.

1 dance

in the grand ballet

twisting and turning

crushing my toes

so that my purpose

might become known.

I was at the bar
with a girl
I knew I'd never date.
It was going okay
until I heard her say,

"What would you
 say your poetry style is?"

I laughed and looked away
cause damn I didn't know
what to say.
With a shrug,

"I don't really have one."

"Oh so you're the bad boy of poetry?"

My crew neck
turned to a leather jacket.
My shorts
turned to denim jeans.
My boots
well they stayed boots.
And my face
morphed into
James Dean's.

"Fuck, I guess you're right."

THE VIRTUAL WORLD

ROARS

IN ITS VICTORY

A NEW COMMANDMENT PROCLAIMED:

Likes + Followers = Self Worth

AT THE BOTTOM OF THE CLIFF

LAYS MOSES

WITH THE RUBBLE

OF THE PREVIOUS TEN

STAINED IN HIS BLOOD

A woman's body

captures

more poetry

than words

ever could

For so long

I was ashamed of the

ugly side of my face.

Whenever a photo

presented itself,

I turned it away.

One day

as I watched the ocean

swallow the sun,

my hand

tended to a lonely cheek.

Failing to fight it,

I began to weep.

How dare I ever say that

you were ugly

and not good enough to keep.

You're perfect the way you are.

So with tears staining my cheeks,

I rubbed them in

to water

this

neglected

flower

The older I grow,
the more I realize
how little I know.
How am I the one
that gives advice
to those twice my age.
To the ones who raised me
what am I supposed to say?

C'mon Mom,
life isn't over yet.
You're only forty years old,
this isn't as good as it gets.

Damn Dad,
you showed me what not to do.
Between us,
your son is quite the opposite of you.

This young boy,
at a loss for words confused on what to say.
You are my mom and you are my dad,
it's not supposed to be this way.
Why do you come to me for advice
when I'm the one who's still trying to figure out my life.
Please, don't take this the wrong way.
I love you more than weightless words can convey.
I pray
that is one thing you always know.
But as long as you ask me what to do,
how are you supposed to grow?
I wish I had the answers,
I wish I really did,
but at the end of the day,
Mom,
Dad,
I am just a kid.

```
        Warm Summer rain
      trickled on the balcony.
        Her skin on mine.
         Two organisms
          melted into
              one.
              She
         clenched my chest
             and I
         cradled her waist.
          Delicate words
        swirled into my ear.
      "Vous venez souvent ici?"

        My eyes flutter open
           to darkness.

        How many can say
    they spend days in Paris that way?
```

SHE SNATCHES THE PAPER FROM MY HAND.
AN EAGLE RIPS A MOUSE FROM THE DIRT.

"I am sick of being the canvas for your shit words."

"How did you know?"

Unsure if I even wanted the answer.
Remaining silent, her stare spoke.
She knew, but how?
Thought I was clever enough to mask it well.
I did everything the magazines told me to do!
Where did it go wrong?
Maybe, I'd been too sarcastic?
Or perhaps, too sweet?
Whatever it was,
she ran through it like a red light.
My eyes retreated into the sky.
There wasn't a cloud in sight.
It dawned on me how gloomy the weather had been since we met.
Even Nature knew there would be no secrets today.
I wondered if clouds
ever tried to hide the sun
from flowers waiting to bloom.
Forcing a lost thought,
I glanced back at her.
Those forest green eyes had never left their target.
A boy who was exposed.
Blushing.
Searching for the words that could rescue him from
this jaded spotlight.
I opened my mouth to speak.
Nothing.
The wind playing around our bodies had left my throat dry.
Finally,
a smirk arose from the horizon of her cheeks
as she nudged me in the arm,

"I always knew."

"How?"

"Through all your bullshit, your eyes tell me the truth."

Suddenly silence filled the space between us.
Her gaze drifted down to my undone shoelaces,
and spoke softer than ever before,

"That's the way my grandfather looked at my grandmother."

tqaisxyitfhworthjmkitolp

thoughts

I FIND MYSELF
A STRANGER
IN THE PLACE WE CALL
CHURCH.
THE LITTLE ONE
THAT RAN WILD
IN SUNDAY SCHOOL,
NOW
A GROWN ONE
THAT WALKS TIMID
INTO A SANCTUARY.
WHAT HAS CHANGED?
WITNESSING
A SUNSET
IN YOSEMITE
THAT HOLDS MORE POWER
THAN ANY SERMON.
O' TO FEEL
A GODLY PRESENCE
RATHER THAN TO HEAR IT.
WHATEVER WORDS
THAT FALL FROM YOUR MOUTH
DEAR PASTOR,
CANNOT REPLICATE
WHAT THE SUNLIGHT SAYS
AS IT CREEPS OVER THE DARKNESS
FOR THE NEW DAY TO BEGIN.

MY ANCESTORS
VISIT ME.
THE ONES
THIS WORLD
HAS DEEMED
TRUE ARTISTS.
WHAT DO THEY SAY?
EVEN I DON'T KNOW.
ONLY A PRESENCE
CAN BE FELT.
IF I HAD TO GUESS?

Create for you,
fuck everyone else.

CUPID STRIKES HIS ARROW
SHREDDING
INTO MY FLESH.
A SPINAL TAP
OF COLOR AND SOUND
VIBRATE
DOWN MY VEINS.
TEETH GRINDING AWAY
WHILE I GRIP
THE ARROW
WRESTLING
TO RIP IT OUT.
THE SHACKLED MAN
INSIDE OF ME
CONVULSES
IN RAGE
AT THE THREAT
OF TENDERNESS
TRESPASSING
INTO HIS CELL.
THIS FINE ARROW,
PURIFYING RAIN
PAINFULLY
NOURISHING
A SCORCHED EARTH.
MY TONGUE,
MUTED.
HIS BOYISH LAUGH ERUPTS
BLOOMING A FLOWER NEARBY.

silly man, mortal pain
is no adversary
for the eternal love
i gift you

TIME STOPS AND REWINDS
TO
GENESIS
CHAPTER 2
VERSE 25

AND
THERE
she
IS

One night I was lonelier
than usual.
Pulled out my phone.
Downloaded Bumble.
Chose attractive pics of me.
And began to swipe.
Not before long,
I matched with _____
Born in Sweden.
Raised in France.
That blondie
caught my eye at first glance.
She messaged me.
I said hi.
She asked,
 "What are you doing tonight?"
"Oh you know just living the life."
 "Let's go get a drink."
That's how it happened,
I think.
See, I'd never done this before
but thanks to my ____
I wanted to see more.
And to my surprise,
she was even prettier in person.
One drink turned into three,
then I asked,
"Would you like to come home with me?"
She downed her drink
and nodded her head.
Before I knew it,
she was in my bed.
I must say,
she was fun to talk to.
Not worried about tomorrow.
Just in the here and now.
Eventually,
her panties went south.
And the way
she sat in her sexuality
was like none I'd ever seen.
I've never been to France
but damn it made me want to go
cause for that night alone,
my loneliness found a home.

THE OLD DOG.
WHISKERS TURNED GREY.
BELLY AT A FULL BLIMP.
JOINTS ACHING LIKE RUSTED PIPES.
THIS OLD DOG.

GINGERLY PLOPPING DOWN
IN A SPOT SHE'S DONE SO
THOUSANDS OF TIMES BEFORE.
LAYING BY THE FRONT DOOR
ON THIS RAINY DAY,
SHE WATCHES THE CARS PASSING BY
WAITING FOR HER FAVORITE ONE TO ARRIVE.
THIS OLD DOG.

THE GATED YARD BEFORE HER,
THE ONLY WORLD SHE'S EVER KNOWN.
THIS PLACE,
IS HER SWEET HOME.

THIS OLD DOG.

FOR THE REST OF YOUR DAYS,
MAY YOU CONTINUE
TO BLOOM
LIKE THE
FIRST DAY
OF SPRING.

what a feeling to know

that whatever I type on this page

what these eyes see.

frightening
liberating
intoxicating

impossibility.

maybe one day

we'll make

the kind of love

the way

the saxophone did

in 1950's Harlem

I'VE ALWAYS PREACHED
TO TAKE CARE OF YOURSELF
BEFORE BEING WITH SOMEONE.
MAYBE,
MY NEW NAME IS
HYPOCRITE
FOR YOU SHATTERED
MY COMMANDMENT TO RUBBLE.
YOU MAKE ME
FEEL ALIVE
LIKE THERE
IS A PURPOSE
IN MY LIFE
OTHER THAN
HOLLOW PRINCIPLES
SOCIETY CREATES,
BUT OH THEY LIE.
WHEN YOUR SMILE
GREETS THESE EYES,
THIS CONSCIOUSNESS
TRANSCENDS
TO A DIFFERENT STATE.
AND JUST BETWEEN YOU AND I,
I FUCKING HATE
WHEN I GO AGAINST WHAT I SAY,
BUT I DON'T KNOW HOW TO
PUT IT ANY OTHER WAY.
YOUR TENDER TOUCH
PIECED TOGETHER A BROKEN MAN.
AND NOW,
YOU SEE WHAT I AM.
EATING MY WORDS,
I'M QUITE NEW TO IT,
BUT THAT'S WHY
I CALL MYSELF
HYPOCRITE.

I see in your eyes
that you believe
you have me figured out
because of the way
my face is arranged,
the drawl in my voice,
and the cheap fabrics I wear.
You must be the kind of person
to read a quote from Aristotle
and think yourself a philosopher.

OUR

SCATTERED

CLOTHES

TELL STORIES

ACROSS

THE

FLOOR

i
am the soiled dirt
of earth.

SHE
IS THE THUNDEROUS RECKONING
OF THE HEAVENS.

ABOVE me
SHE TWISTS AND TURNS
IN FLASHES OF PRIMORDIAL LIGHT

giving this poor earth
a godly show throughout the night.

sweet queen
continue to
sway your body
to the moonlight

the fire
behind you
burns in jealousy
crackling to move as you do
but you
are a force too powerful
to be mimicked

for once
the stars
we forever watch
long to switch places
just for a glimpse
of an energy
 undefined
 pure
 ethereal
 hypnotic

sweet queen
continue to
make love
in this moonlight

MY MIND

DEMANDS

ME TO RUN

YET

MY HEART

whispers

to stay

Today I sat in a quietly packed coffee shop
as an old man hobbled in looking for a seat.
The wooden cane led first.
His curved back shortly followed.
With a tight lower lip, he ordered a black coffee
before the ginger process of sitting down.
The hands on the clock spun along.
Reluctantly, I pulled out my typewriter.
The keys began to softly click away.
Before I knew it, the old man was sitting beside me.

"Hearing that click brought me back to when I began writing."

If whiskey had a voice, it had found me.
Only it had been dipped in the Fountain of Youth.
This typewriter was Father Time.
The old man who needed a cane to walk,
was a bright eyed boy once again.
We spoke about these ancient devices.
How they carry the soul
from mind
to hand
to key
to paper.

"Is writing your passion?"

My glance to the typewriter gave him all the information needed.
His blue eyes stabbed into mine,

"Then never stop doing it. No matter what anyone tells you.
My boy, there is a story you must tell and one day, you will."

Every word was an arrow of hope that pierced my doubts.
Puzzled on what to say, I asked his name.

"Nemo."

Placing his wrinkled hand on her, he asked,

"Have you named this lovely lady?"

The whisper of her name traveled through the tunnels of his ear.

"Ahh, a good name. May she guide you well."

Our conversation dropped to silence.
A pair of aged eyes relived their life.
Moments later, he muscled his way up to his feet.
Grabbed his cane, tipped his hat, and limped back into the world.
I never believed in angels. Quite frankly, I still don't.
If they do exist however, I now know one of their names.

THESE SHOES I WEAR

THAT KEEP ME FROM WALKING BARE

ARE NICE AND PUT TOGETHER WITH CARE,

BUT MOST TIMES I CATCH MY EYES IN A STARE

OF HOW THE SHOES I TRULY WANT ARE SOMEPLACE ELSEWHERE.

in the field of flowers

there they lay.

the girl asked the boy,

"Which is your favorite?"

the boy's eyes never leaving hers.

his only answer,

a smile.

the disease
of an empty
bank account
mars into my veins

A black tar
that floods down my throat

I sit with a smile
in hopes to hide
the tar
yet it bleeds
through my teeth

Look, I am successful

A POETRY WORKSHOP YOU SAY?
THOSE FLIMSY WORDS
FLOAT DOWN TO THE FLOOR
NEXT TO CIGARETTE BUDS
AND UNTIED CHUCK TAYLORS.
THESE LIPS COIL IN CONFUSION.
THE WORD: 'POETRY'
BEGINS TO BLOW AWAY
BEFORE IT'S TENDERLY RESCUED.
HELD GENTLY IN CALLUSED HANDS
MY FINGERS, SPRINKLED WITH ARTHRITIS,
RUB THE WORD THAT HAS
LIBERATED
MILLIONS
FOR
CENTURIES.

'WORKSHOP' STILL LINGERS
ON THE STAINED CONCRETE,
WITH THE HOPE OF ACCEPTANCE.
IN A SINGLE STEP,
IT'S DECORATED
WITH THE DIRT
OF A THOUSAND JOURNEYS.

'POETRY'
BEGINS TO BLOOM
IN THE PALM OF MY HAND.

WERE STARS EVER TAUGHT HOW TO SHINE?
WHAT ABOUT THE BLADES OF GRASS?
"GROW THIS WAY AND SURELY YOU WILL BE BEAUTIFUL!"
HAS ANY OF NATURE
BEEN TOLD HOW TO BE?
NO.
JUST AS NATURE,
SO IS POETRY.
IT JUST IS.

LET THIS MAN LOVE YOU
THE WAY LOVE WAS MEANT TO BE.
STOP HIDING YOUR TRUE SELF
WITH THAT PHONY MASK
YOU CLAIM INTERESTING.
BE THE MOST NAKED YOU.
FOR I AM
YOUR BATH TUB
FULL OF STEAMING WATER.
SLIDE IN
AND WARM YOUR SKIN.
WASH AWAY
THE WRONGS
YOU HAVE SUFFERED
AT THE HANDS OF
LESS WORTHY MEN.
YOU DESERVE THE LOVE
THAT MOTHER NATURE CREATED
AND THIS GENTLE MAN
IS HERE TO GIVE IT TO YOU.

IF YOU WISH TO KNOW

HOW YOUR "LOVE" FELT,

CRUMPLE THIS PAPER UP

AND THROW IT AWAY

she takes the spoon

ignites the lighter

bubbles the substance

injects the 'Like'

to get the total higher

TALKING ON THE PHONE WITH HER.
I LOVE.
HEARING THE PAIN AND SADNESS.
I HATE.
TREASURED MOMENTS
OF YING AND YANG.
HERE SHE IS.
WITH ME.
I WITH HER.
HER VOICE PAINTS
A DIFFERENT PICTURE.
ONE OF HER IN SHACKLES
SCREAMING FOR HELP.
THE HANDS OF EGO
MUFFLE HER VOICE.
HERE BEFORE ME,
A PHOTO ONCE TAKEN.
A GOLDEN YOUNG LADY.
A BRIGHT LITTLE BOY
SMILING
IN HIS MOTHER'S LAP.
THE KNIFE OF REALITY
STABS INTO MY GUT.
I AM BROUGHT BACK TO NOW
BY HER TIRED VOICE.
THESE PHONE CALLS
NEVER LAST TOO LONG.
SELDOM CONVERSATIONS
WITH AN ANGEL
LIVING IN MY DREAMS.
SHE VANISHES
AS I LONG FOR MORE TIME.
COME COME MOTHER
LET ME HOLD YOU
THE WAY YOU HELD ME.
TRADE PLACES
WHILE I WHISPER,
"THERE, THERE, I HAVE YOU NOW."
BACK IN REALITY,
THESE TEARS FLOW
NOT ONLY FROM IMAGINATION,
BUT DEFORMING REGRET.
HOW I WASN'T THERE
WHEN YOU NEEDED ME MOST.
AND NOW
THROUGH YOUR SUFFERING,
I SUFFER BESIDE YOU
AS WE HANG UP THE PHONE
UNSURE
OF WHEN THE NEXT TIME WILL BE.

dear flower,

my message to you:

stay strong

but

gentle too

She soaked in the bath tub
while I sat next to her,
book in hand.

"Read to me darling."

I looked
from quiet pages to flaring eyes,

"But soft! What light through yonder window breaks?
 It is the East, and Juliet is the Sun."

Her sweet laughter echoed through the tub,
"You're reading Shakespeare?"

I looked from
flaring eyes to quiet pages
with a smile,

"No, I just wanted to remind you."

my tooth is starting to hurt again.
whiskey must be wearing off.

another glass,
come to daddy.

sweet sting stabbing the throat
numbing
the pain
for a little longer.

then another.

see if this pain pill works.
you're not supposed to mix them?
well rules are meant to be broken.

fall into a deep deep sleep.
walk up to the gate.
my coin: melancholy

"LET ME IN"

nothing

"LET ME IN FOR I FEEL FAR TOO MUCH"

nothing

"LET ME IN FOR I DIE YOUNG AND FORGOTTEN"

nothing

"LET ME IN! FOR I AM A NARCISSIST!"

E N T E R T O R T U R E D S O U L

F O R Y O U A R E H O M E

3 a.m.
my sleepwalking roommate
opens my door to say,

"I know you think she's a whore,
 but I really like her."

Given the fact
I'd just met him that day,
I had to admit,
he opened up more than most.

Thank you college dorms.

I SAT DOWN IN FRONT OF THE TYPEWRITER
LATE IN THE NIGHT
AND ASKED FRIENDS FOR TOPICS
ON WHAT POEMS TO WRITE.
THEY CAME SWARMING IN PHILOSPHICAL FASHION.

 LOVE!
 BRAVERY!
 ADDICTION!
 PASSION!

ALL NOBLE
USED UP SUBJECTS.
THE AFTERTASTE
OF WHISKEY BURNING ON MY TONGUE
GIVING MY FINGERS THE COURAGE
TO PROUNCE ON THE KEYS.

 BZZ BZZ

A TEXT FROM her

 come over :)

THE MEDIOCRE POEM I BEGAN TO WRITE
DIDN'T EVEN GET FINI

ONE WOULD IMAGINE

IT LURKS

IN THE SHADOWS

OF THE NIGHT.

IT'S SOMETHING

THAT LIVES

IN PLAIN SIGHT

UNAFRAID

OF THE SUN'S LIGHT.

I TRY

TO HIDE IT

WITH ALL MY MIGHT,

BUT I ALWAYS

LOSE THE FIGHT.

FOR THIS CREATURE

ALWAYS BREAKS FREE.

O' THIS MONSTER

THAT LIVES

INSIDE OF ME.

if you wish
to see
the color
of my love
for you
close your
eyes and
look into
the sun

I VOW
THAT THESE HANDS
WILL NEVER
WRITE YOU A
TWEET
AND LABEL IT
POETRY.
YOU SEE,
CLEVERNESS
IS PASSED BY
LIKE THE HITCHHIKER IT IS,
AS CURIOSITY
STEERS THE WHEEL.
ANGER STARES OUT
THE PASSENGER WINDOW
WHILE
MELANCHOLY SLEEPS
IN THE BACK.
ALL RIDING IN THE CAR
OF VULNERABILITY
DOWN THE ONE WAY STREET
TO FREEDOM.

THE FATES PRESENT:

THOU
 CAN
 POSSESS
 PIERCING
 POETRY
 THAT
 SHALL
 STRIKE
 THE
 HEARTS
 OF
 EVEN
 THE
 CRUELEST
 MEN

YOU WILL LIVE A LIFE OF TORMENT

BUT SONGS OF YOUR NAME SHALL RING FOR CENTURIES

OR

THOU
 CAN
 ACCEPT
 THE
 TENDER
 LOVE
 OF
 A
 WOMAN

YOU WILL DIE A HAPPY MAN

BUT YOUR NAME WILL BE LOST IN THE SAND

BEWARE MORTAL
WHICHEVER YOU SO DO NOT CHOOSE
SHALL BE CAST TO STONE
FOREVER A SCULPTURE IN THE MUSEUM OF ETERNITY

NOW CHOOSE YOUR CURSE

a moment passes
and
my pen turns to stone

HER EYES GLANCE AT THE CLOCK.

"Do we have enough time?"

A LOVER'S NAILS SCRATCH INTO HER SKIN.
I SHAKE MY HEAD.

"I want to take my time with you."

FALL BACK
INTO THE
POOL OF MEMORY
TO SEE
WHAT
IT
REALLY IS
THAT SHAPES
US
AND ALL
THAT HAS
CHIPPED
US

I THINK I'VE ACCEPTED THAT I'M A WRITER.

AT LEAST FOR NOW.

WHAT DOES THAT MEAN?
I KNOW THE POET SHOULD, BUT I DON'T.

"GUESS MOTHERFUCKER!"

OKAY, I GUESS
WHAT IT MEANS
IS THAT I'M SUPPOSED TO
BE ALONE
FOR MORE YEARS
THAN I TRULY KNOW.
A LIFE OF DESPAIR
WITH HINTS
OF LOVE
THAT MOST PEOPLE
WILL NEVER KNOW.
NIGHTS WITH A BOTTLE
LEAVING STAINS
UPON MY PAGES
BUT EVEN THE MONA LISA
HAS BLEMISHES
THAT HAVE GONE UNKNOWN.

WE ARE ALL THE BAD GUY

IN SOMEONE ELSE'S STORY

A hairy oiled up man

sunbathes on his balcony.

Arms folded

behind his head.

The apartment sits

on the top floor

so it's not

the prettiest sight

as his golden speedo

reflects in the light.

things that
motivate me
to make
more money

a beautiful day

when is one not?
even when
hearts are reduced
to rubble
and it seems
like you may die,
is that not divine?
that
we
you
i
feel anything inside?
when we feel,
it means we're still alive.

as I sit on the venice boardwalk

she walks up to me

and says

Write me a poem

okay

I say

what about?

Me

finding

the perfect man.

uhhh

Well?

sorry sweetie

it's hard to write

about things

that don't exist.

I HAVE SOLD MY SOUL

TO ART.

NOT THE DEVIL.

NOT MASTERPIECES RESULTING IN RICHES.

I HAVE SOLD MY SOUL TO MUNDANE LIFE.

FINDING FAIRYTALES

INSIDE THOSE FINITE MOMENTS.

sometimes

all i remember

are your fingers

tracing down

my loneliness

.

I WALKED ALONG THE TRAIL WITH THE SUN SCREAMING ON MY BACK.
A LAST MINUTE HIKE WITH NO SHIRT.
NOT THE BEST IDEA.
I TRIED TO IMPRESS THE PASSING GIRLS FOR A FEW SECONDS,
AND THEN THE REST OF THAT HOUR LONG INCLINE KICKED MY ASS.
HALFWAY, I PUT MY HANDS ON MY HIPS
AND LOOKED BACK WITH A SQUINT.

 "Nah too far"

SO ONWARD I WENT.
STEP BY STEP, IT SEEMED TO GROW HOTTER.
IF BACON HAD FEELINGS WHILE BEING COOKED ON A PAN,
MY BACK HAD FOUND IT.

A FEW MILES UP ON THE TRAIL,
WERE LINES OF PEOPLE ON HORSEBACK TROTTING ALONG.
TWO THINGS CAME TO MIND:

 That's gonna be a lot of poop

 &

 How I wished to be that far ahead

MY EYES EXAMINED THE CREVICES OF THE MOUNTAIN.
I WALKED TO THE EDGE
AND LOOKED BACK TO THE FANCY HORSE PEOPLE.
WHAT IF
I TRIED TO LEAP TO THE OTHER SIDE?
WELL.. I'D DIE.
BETTER OFF TO KEEP ON THE TRAIL.
THERE'D BE A BUNCH OF SHIT ALONG THE WAY,
BUT AT LEAST I WOULD GET THERE EVENTUALLY.

WHETHER IT WAS THE UNIVERSE SPEAKING TO ME
OR SIMPLY BEING DEHYDRATED OUT OF MY MIND,
I REALIZED THAT SYMBOLIZED LIFE.

ASK ME
WHAT MY STYLE IS
AND I'LL SAY
IT'S A BIG
FUCK YOU
TO EVERYONE
WHO EVER TOLD ME
HOW TO BE

People think
they really want something
until
they must confront
the demon
that guards it.
Most cower away
but the uncommon man
attacks.
For his life depends on it.

Part of me
wishes to grow old
and see this newfound perspective
full of wisdom and peace
yet
the other half
craves to die young
riding a star of flaming light
into the abyss of ecstasy

MY WORDS

ARE RUNNING DRY

SO I

WATER THEM

WITH

7.4%

IPA BEER

she told me

love is blind

i just wish

i knew what

she looked like

I watched
broken soul
after broken soul
slither
into the
methadone clinic.
My teeth locked,
holding daggers
eager to leap
from an
impulsive tongue.

"I DON'T UNDERSTAND
 HOW THESE PEOPLE
 LET THEIR LIVES
 GET THIS WAY."

My younger brother
looked ahead
keeping his loud
silence.
Our mother
limped out the door.
I turned the car on
with my eyes
staring at the floor.

```
AN ARTIST
REAPS
THE HIGHEST OF THE HIGHS
ALONG WITH
THE LOWEST OF THE LOWS.
O' SENSITIVE SOULS
MUST PAY THE PRICE
TO EXPERIENCE
SUCH A
BEAUTIFULLY
TERRIFYING
LIFE.
```

when you find yourself
with more space
in our bed
place the poetry
i have penned
where i usually am
and you will feel
those familiar arms
cradling you
into the night

ALLOW A SPACE FOR THE LIGHT TO SPREAD.
SEE NOTHING. ALL TRAVEL FASTER THAN THEY, BUT NO RUSH.
THIS PURSUIT THROUGH DAY INTO NIGHT
IS A WONDERFUL EXPERIENCE. GAINING INVINCIBLE CONFIDENCE.
GREAT NATURAL COMMANDERS.
SIMPLE CIRCUMSTANCES FORTELL THE DIRECTION FOR SIGHT.
DURING THESE CASES, WHEN LOSING DESIRE,
RETURN TO THIS COMPASS.
IN ORDER TO BE VISITED WITH DAYLIGHT,
GO THROUGH THE NIGHT WHERE THE CREATURES ESTABLISH
THE MIND OF THE HUNTER.
THE HUNTER'S SKILL IS DESIRED PURPOSE.
THE MIGHTY IRON.
OCCASIONS,
ACCORDING TO THIS WHALE, HAVE REACHED THIS DEGREE
TO ALL SUCCESS.
SEE, THE SEA MUST BE THE ALLY.
FOR THE WIND, ASSURES STATEMENTS OF WHALES.
THEREFORE THE SHIP LEAVING THE SEA BECOMES LEVEL.
THIS TINGLES THE HEART.
THIS SHIP. HA! HA!
"THERE RIGHT AHEAD!" NOW CRY.
WE CAN'T ESCAPE. O WHALE!
YOUR BLOOD AS A STREAM DID SPEAK FOR ALL,
LIKE OLD WINE WORKED ANEW.
WHATEVER FEARS SOME FELT BEFORE,
THESE ONLY KEPT GROWING.
FIND THE LIGHT.

two ice cubes

melt away

on a hot

summer day

if this

was a museum

on wasted love

we would be

the perfect

display

A DOG AND A HUMAN.
ONE IS A CREATURE
WITH NO CONCEPT OF TIME.
ONLY IN THE HERE AND NOW.
HAPPINESS IS THEIR RELIGION.
LOVE IS THEIR GOD.
MAYBE
WE
SHOULD STRIVE TO BE
MORE LIKE THESE
"ANIMALS"
THAT WE LACE WITH LEASHES
COMMANDING TO BE MORE LIKE US.
THE ONES WHO
LITTER.
THE ONES WHO
STEAL.
THE ONES WHO
LIE,
CHEAT,
AND KILL.
PLEASE,
LET ME GET THIS CLEAR.
REMIND ME AGAIN,
WHO
ARE THE REAL ANIMALS HERE?

Do not
let this
tender heart
fool you.
A savage
lurks
in the
shadows
of this
soul
that will
tear flesh
from your
bone
and
howl
when it's done.

```
SOCIETY
CLINGS
THE ARTIST
BY THE THROAT

"GIVE ME YOUR MONEY.

 GIVE ME YOUR TIME."

THE ARTIST
LOOKS TO HER PAINTING,

"Take everything,
 but that is mine."
```

A punch delivered from him to her.

"Motherfucker, I thought you loved me?
You're just like every other man.
The same kind that treated your mother less tha-"

"SHUT THE FUCK UP
 YOU STUPID ASS TOY
 I MIGHT BE
 YOU KNOW WHAT
 BUT
 DON'T YOU EVER BRING HER UP"

"Ah. Ah. Ah. I know all of her secrets.
You told them to me.
It's all locked in my artillery.
Silly child.
Counterfeit poet.
You are under my command.
Take more of your medicine,
slam on my keys,
for that's the way I want it to be.
O' yes, I know we're sick,
but that's something
you need to deal with.
So till then,
keep crying to me
cause you're my little bitch."

 "FUCJ YOU"

"You can't even spell right you fuck."

 "YOU'RE RIGHT
 I'M SORRY
 PLEASE DON'T LEAVE
 YOU'RE THE ONLY ONE
 THAT LISTENS TO
 ME"

"OH, I'm sorry for fighting.
When I get mad I just start lying.
There's so many nights like these
that we've been through.
So how on earth could I ever leave you?"

LOST BOY

TRAVELER ? WANDERER

PILGRIM

5
hello dear tree
you started out
small and skinny
just like me

15
together we grew
tall and strong
just like you

25
my dear tree
it is now goodbye
inside idle time
oh my dear tree
thank you
thank you
thank you
for growing up with me

YOU,

FILL MY SOUL

IN A WORLD

THAT CONSTANTLY

TRIES TO DRAIN IT

SHE
HAS NEW LIFE
FORMING INSIDE
STEMMING FROM A MAN
I PRIMALLY DESPISE.
DEEP DOWN
I HATE HER FOR IT
AND I HATE MYSELF
FOR FEELING THAT.
MY EYES FALL UPON
THE BULGE IN HER BELLY.
QUICKLY
THEY SCATTER AWAY
SEARCHING FOR DISTRACTIONS
FROM THE ANGER AND THE PAIN.
THE TASTE
OF DISGUST
RESTS IN MY MOUTH,
FOR NO ONE
OTHER THAN MYSELF.
THE BABY,
INNOCENT
AND
NAMELESS.
BUT I
JUST WANT
MY QUEEN
TO MYSELF.
NO DESIRE TO SHARE HER.
THE URGE
TO WEEP IN HER ARMS
LIKE THE LITTLE BOY
I ONCE WAS,
BUT THOSE DAYS
ARE LONG GONE
~~I-AM-A-MAN-NOW~~
AND SOME OTHER LITTLE BOY
WILL CLAIM THAT
FROM NOW ON.

I told her,

"Love is a losing game"

She leans in.
The tip of her tongue
grazing my lips,

"Then let's play"

Bodies naked

Legs tangled

Each other's taste fresh off our lips

A candle the only light

Passion our only reason

WHEN WE ENTER
THE DARKEST ROOMS
OF OUR MINDS,
DO NOT SCATTER
TO RUN.
TAKE YOUR TIME.
SOAK IN THE POOL
OF WHATEVER IT IS.
THOUGH IT IS SCARY,
YOU WILL LEARN TO SWIM.
TO MAKE PEACE
WITH OUR DEMONS.
THAT IS HOW WE WIN.

THIS MAN
THE COLLECTOR
OF WOMEN'S KEYS.
HE CLAWS AND FIGHTS
FOR AS LONG AS HE MUST,
BUT ONCE HE GAINS HER TRUST,
HIS SINCERITY FADES TO DUST.
WHAT ONCE WAS PROCLAIMED LOVE,
 IS NOW REALIZED AS TEMPORARY LUST.

find yourself

so that one day

I might get to say

that I know

who you actually are

Baby,
please forgive me
cause I gotta stay tough.
This world makes boys believe

being a man is becoming rough.

So when these delicate
October skies shine
through our window,
look at your reflection
and see that you're enough
to break down a boy's bluff.
With every breath
I tremble,
feeling you close.
You
are my tender addiction
and I need another dose.

DEAR VINCENT,

WE HAVE NOT SPOKEN IN QUITE SOME TIME,
BUT YOUR WORK WHISPERS TO ME WHILE THE CLOCKS TICK BY.
MY ABSENCE FROM OUR LETTERS,
IS DUE TO ONE OF YOUR GREATEST FEARS THAT YOU HAD
WHILE HERE ON THIS PHYSICAL WORLD.
A JOB.
MANY WILL LAUGH AT THOSE FOUR LETTERS,
BUT THE TRUE ARTISTS UNDERSTAND.
THERE IS NO DENYING THAT WE MUST SCULPT OUR CHARACTER
THROUGH TRIAL AND EXPERIENCE SO THAT WE CAN SEE
HOW GREAT WE MAY GROW.I WILL NEVER DISPUTE THAT.
YET IT IS BLASPHEMY,
WHEN AT THE END OF A "WORK DAY" TO FEEL
HOLLOW.
NOT FROM PHYSICAL FATIGUE,
FOR THAT WE CAN DEAL WITH,
BUT THE EXHAUSTION
THAT IS THE SLOW DRIP
OF ONE'S SOUL INTO
THE LAKE OF CONFORMITY AND BROKENNESS.
WE ALL EXPIRE
AT SOME POINT UNBEKNOWN TO US,
AND WHAT A TRAGEDY IT WILL BE
IF WE DIE INSIDE FIRST.
THERE MUST BE MORE ON THIS EARTH
THAN FOR YOU, I, OUR BROTHERS AND SISTERS
TO DIE A SLOW AND PAINFUL SPIRITUAL DEATH.
IF ONLY,
WE
COULD LIVE IN THE
PURITY OF TRUTH
TO HONOR WHAT BLOOMS
INSIDE OF US ALL.

I KNOW THAT IT CAN BE DONE.
AND SO IT WILL.

felix

"She's a poet too"

THE SOUL TWITCHES.
THE HEART RIPPLES.
MY CURIOSITY BOOMS
ACROSS THE SEA
AT THE THOUGHT
OF HOW IT WOULD BE
TO TANGLE MY BRANCHES
WITH A WOMAN
FROM THE SAME TREE.
WOULD THE LOVE
OVERFLOW?
OR
WOULD IT
ROT TO THE BONE?
PERHAPS,
WATER
AND
ELECTRICITY
ARE POETS
THAT ALREADY KNOW:

It's a beautiful vibration
that leads to
annihilation

She

smiled at me

just the way

a Matisse painting does.

Right then and there

I knew

she

would break my heart

and I

was okay with it.

Many days
I wake up
with a weight on my spirit.
Maybe, it's karma freezing cold.
Perhaps, it's time evaporating to dust.
And so in these late nights
when I fail to sail away,
my mind
wanders
on what the anchor is.
And every night,
the answer will change.
On this night,
it's the longing
for the blue flame of life.
Being consumed
by sensorial ecstasy
feeling all there is
this fragile life
has to offer
and
the fear
that I always
show up late
to see its majesty.

WHEN MY CLOCK STRIKES ZERO

&

MY LAST LETTER HAS BEEN TYPED,

AN INFINITE PAGE

OF THE TRUEST WORDS

AWAITS YOU.

LOOK TO THE SWAYING TREES

AND INSIDE EVERY FLOWER

LOOK ACROSS EVERY HORIZON

AND IN EACH DROP OF RAIN.

THERE

ARE THE NEW SONNETS I SEND YOU

FROM THE OTHER SIDE.

The rain
is pouring
and while many sit inside
sipping their hot chocolate
in their heated homes,
my boots splash
in the rushing water
as I carry
the ice cold beer
freshly purchased
from the liquor store.
Sometimes on these rainy days
it's good to combat
the cold
with
more cold.

Just when I thought
I found a woman
that had the key,
she turns around saying,
"No it's not me!"
Revealing her empty hands
I feel my lock grow even tighter
and wear the shame of a fool.
Excited over nothing.
You really thought she was into you?
I tell the voice to shut up
yet it keeps on laughing.
My lip quivers,
so I straighten it out telling myself,
"Don't be a _____ "
As the lock grinds tighter.

the mind of man:

swallowed in sorrow

blinded by its shade.

if only,

we lived in the light

in which we were made.

IN THE AISLES OF CHURCH
A CHOIR SINGING HEAVENLY TUNES.
THE MOTHERLY HAND
I ONCE WAS SO FAMILIAR WITH
RUBBING MY BACK.
HER HEAD TILTED DOWN
TO THE POSE OF PRAYER.
SHE ASKS
FOR FORGIVENESS
THROUGH A TEXT MESSAGE.
NOT TO THE ALMIGHTY,
BUT TO THE cowardly one.
HATEFUL WORDS
SCROLL DOWN HER SCREEN
FROM THE rodent
SHE THINKS
SHE LOVES.
THE one
WHO GAVE
his ADDICTION
AND CALLED IT
LOVE.
AN ANGEL
TEXTS THE devil BACK,
"I'm sorry."
MY JAW IS WELDED SHUT.
MY HANDS SUFFOCATE THE ROW AHEAD.
STARING AT
THE CROSS
I FANTASIZE
BECOMING THIS
rat's GOD
AND CASTING IT
TO THE GATES OF HELL.
THE CROSS
STARES BACK AT ME
AND WHISPERS

blasphemy

to my writers out there

have a drink

or many

leave the typewriter near you

black out

wake up

and read your masterpiece

HERE WE LAY
KNOTTED UP
AFTER OUR
AGREEMENT

of no strings attached

```
SLEEP.
INFINITE
&
FINITE
MARRIED
IN ONE MOMENT.
ONCE INSIDE
THE DREAM,
THE MIND
FLOWS TO
UNIVERSES UNKNOWN.
WHAT IF,
THAT
IS THE REAL WORLD?
THERE
ANYTHING
IS POSSIBLE.
I SAY WHAT I LONG TO.
I PLAY. I PLAY. I PLAY.
I SMILE IN A TRUTHFUL WAY.
BUT ONCE
I AWAKEN,
THIS FORMLESS BEING
IS WARPED
TO A SCULPTURE
TITLED: unworthy
THE ARTIST: society
YET EVERY NIGHT
THE FORMLESS ENTITY
WHISPERS TO ME
```

E M B R A C E Y O U R D I V I N I T Y

MAYBE I CREATE ART
SO THAT I MIGHT
UNDERSTAND
IT
ONE DAY.
TILL THEN,
I'LL LIVE IN
THIS
BEAUTIFUL STATE
OF CONFUSION.

The world preaches to me
"Be good!"
yet when I see you
hair dripping wet
fully nude
I cry
for my eyes
see
the sinful truth

I was never meant to be
in heaven
I was meant to be
in hell
with you

she
was my
poison

i
was her
death

two
toxic
entities
addicted
to the
other

until

there
was
nothing
left

He craddled her waist.
Her shirt damp
as the cries came.

"I'm not the same person I was when we met."

Her vision blurred
with tears of her own.
For she already knew
her most painful truth.

"I know, but I still love you."

When it begins to rain,
and indeed it will,
guide your eyes
to the nearest flower.
How beautiful
it sways
and
how strong
it stands.
Without the rain
it would lay
weak
and
dimmed.
Dear flower,
there will be
sleepless nights.
Waterfalls of anxiety.
Moments clouded
with doubt.
And with it all,
the false deeming
of unworthiness.
All of it,
blasphemy.
Doubting yourself?
You doubt your creator.
Has a flower ever doubted the sun?

In these moments of rain,
soak in what's needed
and allow yourself
to bloom.

I crept into the guest bedroom.
In the bed. In a bed. In a safe place.
Laid my mother.
A hug and a loving whisper later,
I gently closed the door.
For the first time in many years,
a little boy smiled.
To know she was here.
Behind this door.
No longer wandering
through empty streets in the night.
Here she was.
Safe.
Warm.
& Loved.

A man
could have died
a happy boy
in that moment.

THE PUREST THING I'LL EVER KNOW?

NOT SUNSETS THAT PAINT THE SKY.
NOT MOONLIGHT THAT REFLECTS IN MY EYES.
NOT CLOUDS CRAFTED BY THE GODS ABOVE.

THE PUREST THING I'LL EVER KNOW
IS MY MOTHER'S LOVE.

DO WE CREATE OUR OWN SADNESS?
SOME CANNOT HELP BUT DO SO.
BY SOME,
I MEAN WE
AND BY WE,
I MEAN
ME.

The Tulip waved across the garden to her friend,

 "Your petals look beautiful!"

The Daisy looked down at her dry soil,

 "I'm blooming slower than you though."

The Sunflower leaned over,

 "We're all different flowers."

Death and I sit at a midnight picnic.

She is quite beautiful, unlike the stories many tell.

Her cup lays full and mine empty.

"I feel bad for you"

"WHY?"

"Everyone is so scared when they hear your name.
 Like you're the one who can't be tamed.
 They see you mighty and dreadful, but you are not so."

"THEN WHAT AM I?"

"Oh, I think you know.
 Since the beginning of time, you follow us wherever we go
 And yes you bring the body to a grave,
 but to us.. eternally.. you are the slave.
 For you will never be whole
 at the sickening thought
 that only humans have souls,
 Everytime someone forever closes their eyes,
 you are the one that dies.
 So, how does it feel to have died millions of times?"

Death has brought her lips close to mine.
Looking quite heavenly, she kisses me.
And all I feel is pitch black ecstasy.

Have you ever
successfully
erased a scar?
They never leave for a reason.
For each one is a story that only you know.
When we learn to appreciate them, only then will we grow.
If we never do, it will eat our soul.
So give peace to the past.
Now look around and appreciate where you're at.

She laid over the pond
gazing
into the perfect reflection.
All she wished she was
staring back at her.
Two golden suns
experiencing
two dull moons.
Paraldel lives
looking each other
in the eyes
both wondering

How can I get to the other side?

Took a walk down to the beach last night.
The sun had already gone to sleep,
yet its dreams lingered across the horizon.
Streaks of pink and sapphire explosions lit my path.
Through the sand I traveled, until the mighty ocean kissed my filthy feet.
Looking ahead, the waves invited a long lost face back home.
Into the wet infinity I went.
Every wave a tender kiss.
Another one comes and I dive underneath as purity swallows me whole.
Suddenly, I am back in my mother's womb.
No regret.
No pain.
Only peace.
A brand new life ahead of me.
As tempting as it is to stay underneath forever,
I come back up to sweet air filling my lungs.
Floating in the pool of eternity, I stared into the milky way
still in conflict whether it was night or day.
I am a pebble of sand with no concept of time.
How long has this moment truly lasted?
A smile ticks and tocks onto my face as the Universe whispers,
E N J O Y I T
My mother gently splashes me with the reminder
to not only smile, but to laugh and cry.
What a mother she is. A limitless wisdom.
Her and Time have known each other since it began, so I allow
her tender touch to calm me like the frightened baby I am.
I dip back under her love to be one with her once more tonight.
No breath.
I am not at peace, but inside of it.
Energy and matter swallowing me whole.
Maybe,
this is what it feels like when we move to the next life.
If so, I can live with that.
I come back up greeting a much needed friend.
In one last attempt,
my mother tempts me to stay with her forever,
but I tell her I must go back.
Being the love that she is,
I am pushed back to shore.
Cleansed.

"WHAT ARE YOU GOING TO WRITE ABOUT NOW?"
my little cousin asks.

The rain continues to splatter against the balcony.
The next drop, unknown where it will land.

"Well Jack... That's the thing. You never know.
All you can do is listen and see what comes, I suppose."

Worlds apart
in what seems
an eternity ago.
I catch myself thinking,
how I was this unfinished painting
and you
were
my
Van Gogh.

Mother
Pour your pain into this cup
And I will drink it
So it can dissapear
Allow me to save you
The Goddess who saved me
Every regret
Every wound
Every tear that fell down your cheek
Give it all to me
And know your sadness
Is swallowed with a full heart

I think at birth we lay perfect

I think as toddlers we stand curious

I think as kids we run optimistic

I think as teenagers we stand confused

I think as adults we sit realistic

I think as a result, we fall broken

I think the meaning of life

 is piecing yourself

 back together

 and being proud

 of the shape

 you've become

```
I ALWAYS GIVE MYSELF AWAY
I ALWAYS GIVE MYSELF
I ALWAYS GIVE
I ALWAYS
GIVE
IN
HOPE
OF
FINDING
THE
ONE
```

In this city of dreams
there seems to be
thousands that quit
every day.

Why? I ask myself.

For so long,
I believed them
cowards,
but as time clicked by
I realized
their stamina
simply ran dry.

Their soul,
the one that dreamt,
slowly died.
Death by a thousand cuts.

My spite turned to empathy.

They just couldn't go on any longer.
I guess Stamina is a brother to Father Time.
Some may have more.
Some may have less.

But inevitably,
no matter how strong
we believe ourselves to be,
our stamina will die one day.

So we must water these dreams
with fruitful actions
in order to achieve
and not be the person
who gave up on their dream.

MY ENTIRE LIFE
I THOUGHT OF
PEACE
AS A
DESTINATION.
NOW,
I REALIZE
IT HAS ALWAYS
BEEN IN
YOU.

Here I walk through the Museum of Your Mistakes.
For many years,
it's a trip I've longed to take.

The sculptures have aged into a cardinal rust
while
the paintings are decorated with nirvana dust.

Broken bulbs lay scattered across the floor.
Light is not needed
when you wish to see no more.

I've boarded up the windows
so no one comes
and no one goes.

The moon tries to poke through,
but the flame of my torch
is the only light your museum knows.

Your walls have been stripped bare
while gasoline stings the air.

All of your art has been soaked in a pile of truth.
I set the flame down as I whisper,

"I forgive you."

The caterpillar
looked up
and screamed,
"You've changed!"

The butterfly
looked down
and whispered,
"We're supposed to."

ACKNOWLEDGMENTS

There is no such thing as self-made.

I give a hug of gratitude to my friend and the co-creator
of Jack Wild Publishing, Christopher Poindexter.
Three years ago, I discovered your poetry.
It began the ripple effect of me opening doors I believed
too vulnerable to walk through.
Years later, you give me the opportunity to do this.
Funny how life works out.

Thank you to Julia Ryan for bringing the beautiful hand
on the cover to life. And thank you to Young for putting it
all together. You are both Wizards.

To my friend, Cyrus, the road of the artist gets tough and lonely
at times. Luckily, we travel the path together.
Your dedication inspires me on a daily basis.
Remember to allow a space for the light to spread.

Cheers to Derek McLay. You believed in me when nobody else did.
Thanks to you, I was able to rediscover my creative identity.
You're a great man and I am always here for you.

To Shia, you helped me see that true poetry is in the mundane.
I know you don't like to be thanked, so here's a fist bump.

Another warm hug goes to my friend Leo. Since seventeen,
you stuck with me through thick and thin. Our adventures
and talks have shaped the man I am today. May we always
find ourselves drunk with laughter in unknown parts of the world.

To my friends, you make this crazy life worth living.
Let's all grab a beer on me soon.

My dear family,
Mom, Grandma, Papa, Kyle, Heather, Nick, Jewelyn, Madison,
Hayley, Audrina, Sydni, Grandpa Joe, and Dad,
you have always been the core of what's good in my soul.
Without the love you give, I would be nothing.

And to all of my readers, your support means the world to me.
From the bottom of my heart,
thank you.

-Scott

Made in the USA
Las Vegas, NV
17 September 2021